This book belongs to

_____

For Joel and Lacey Binion, who
I love with all my heart.

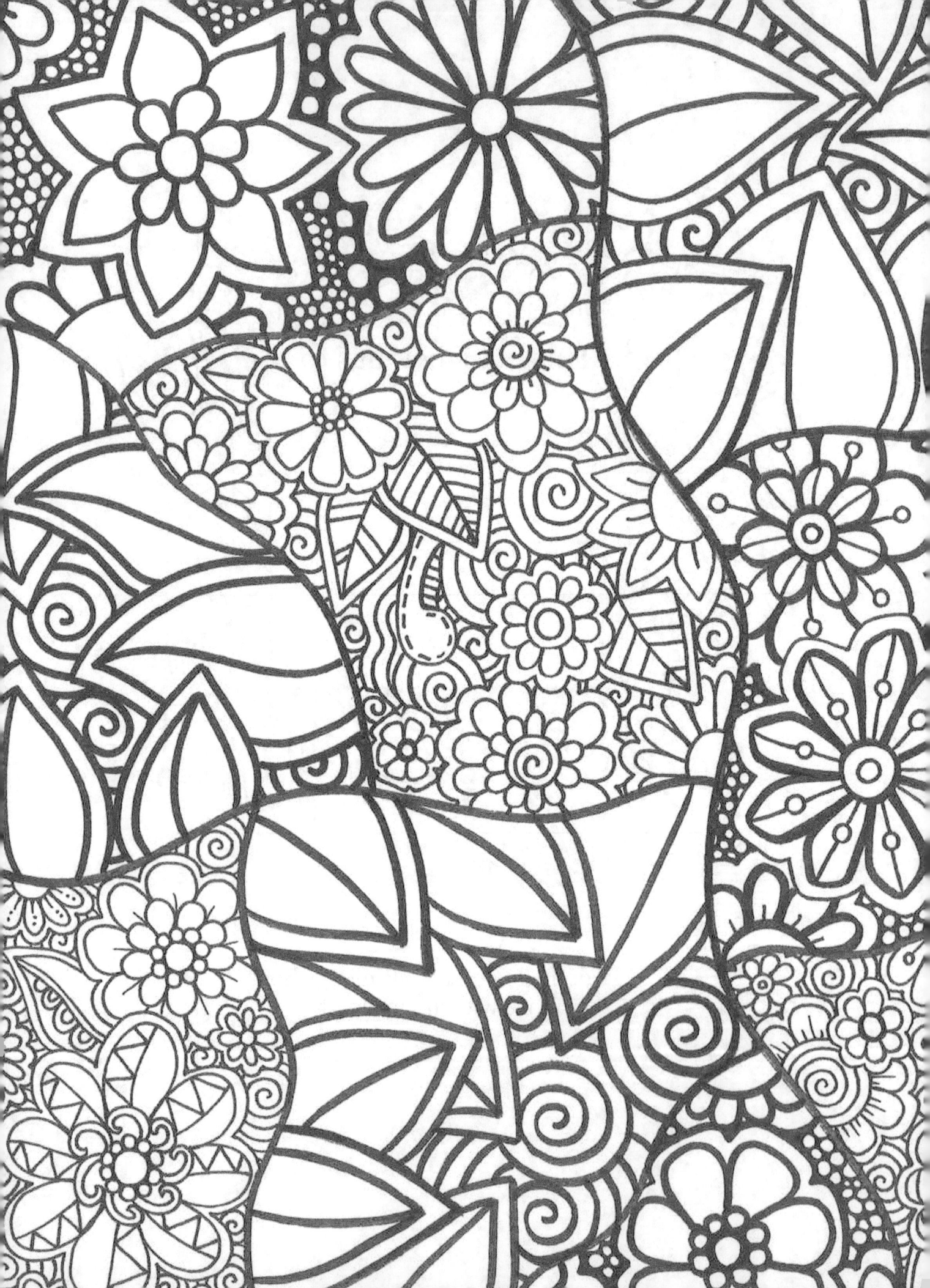

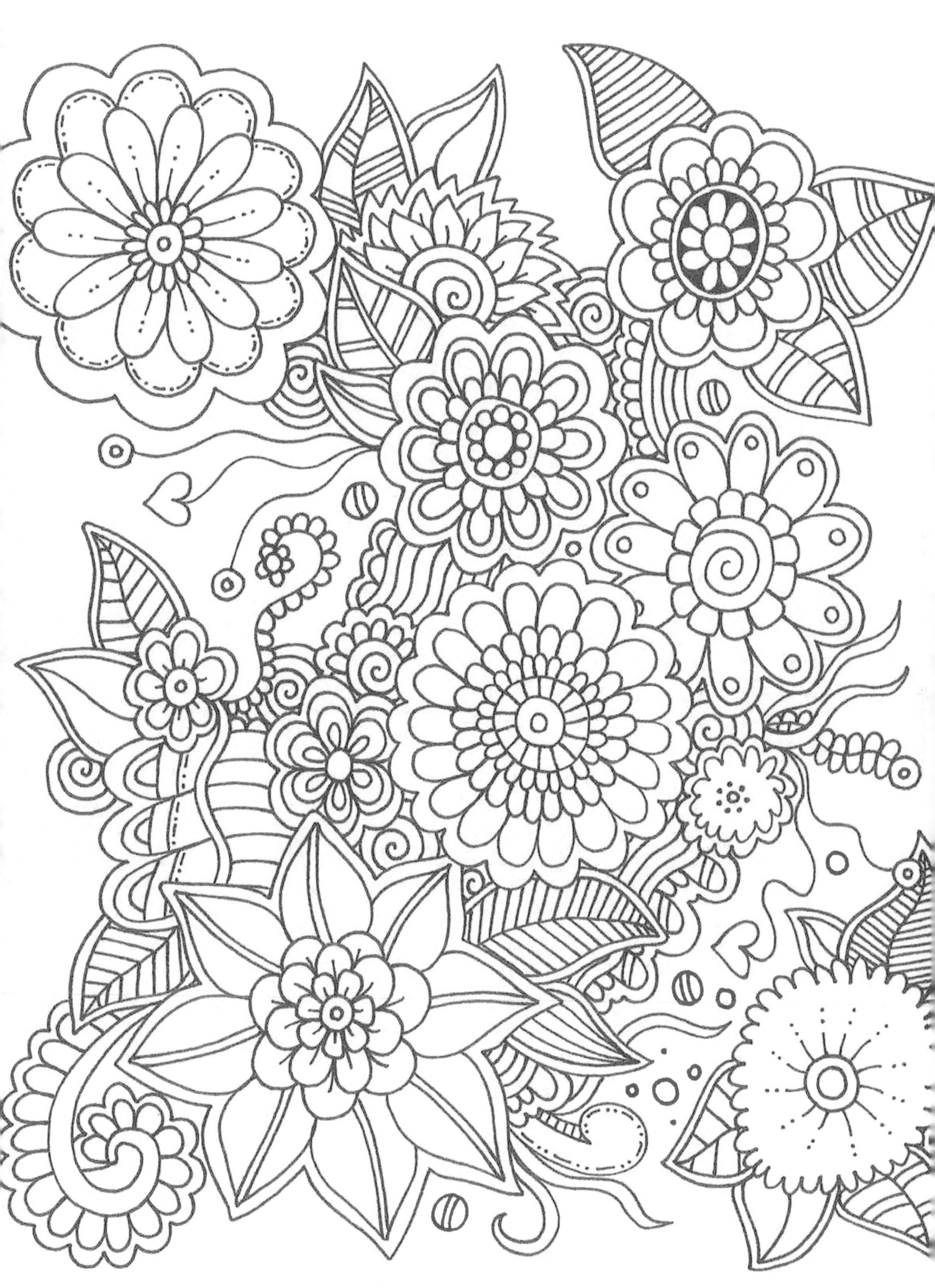

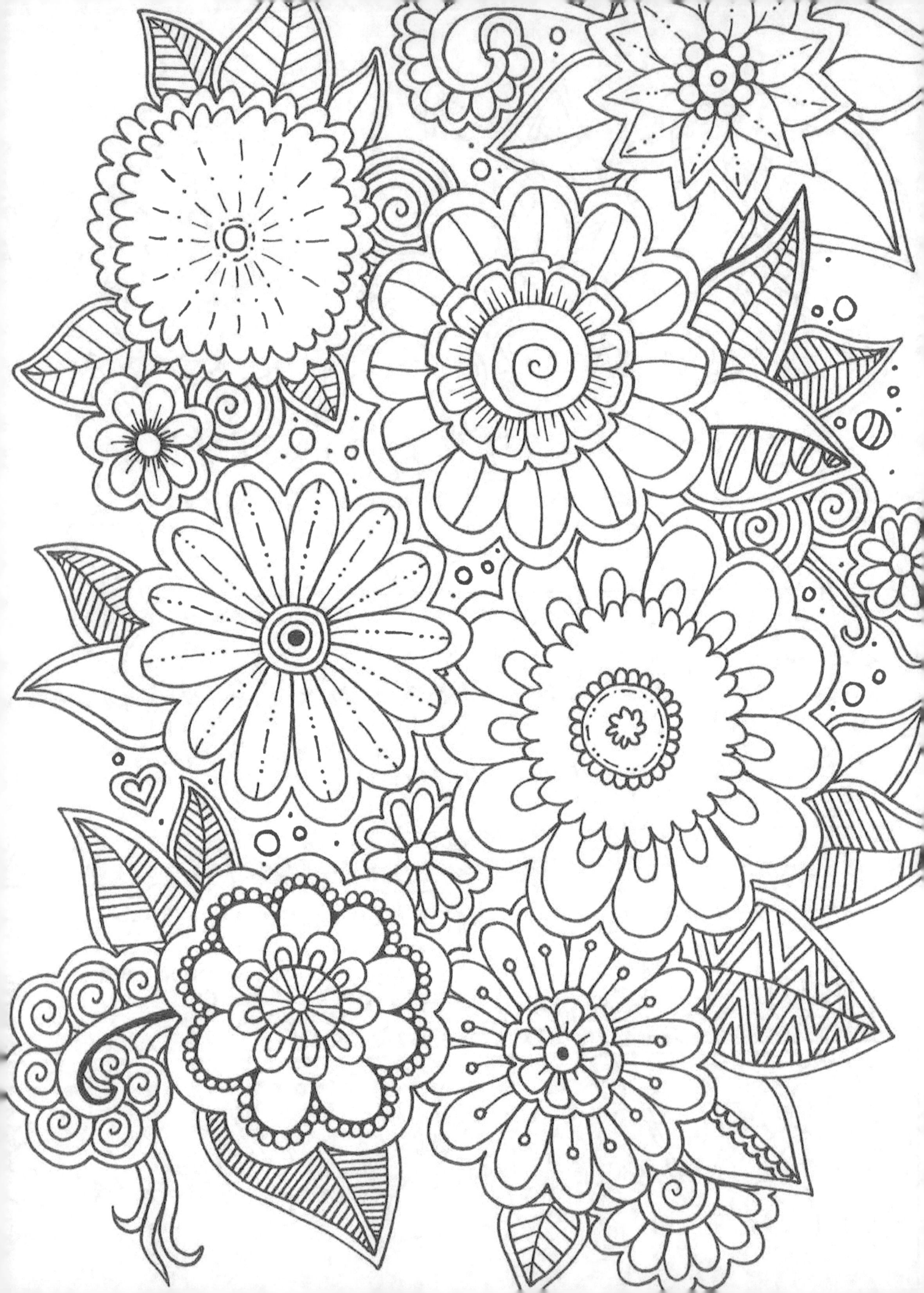

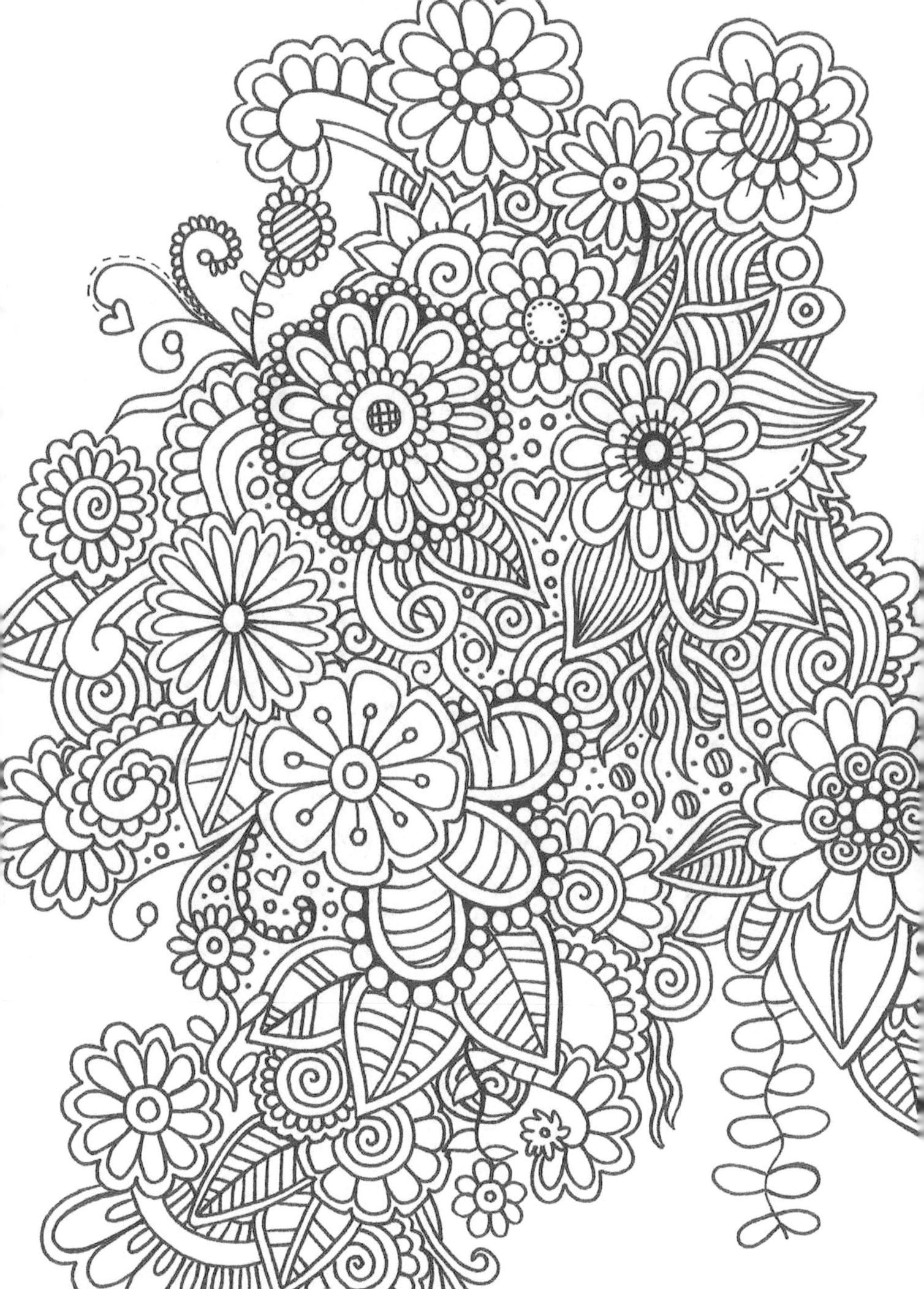

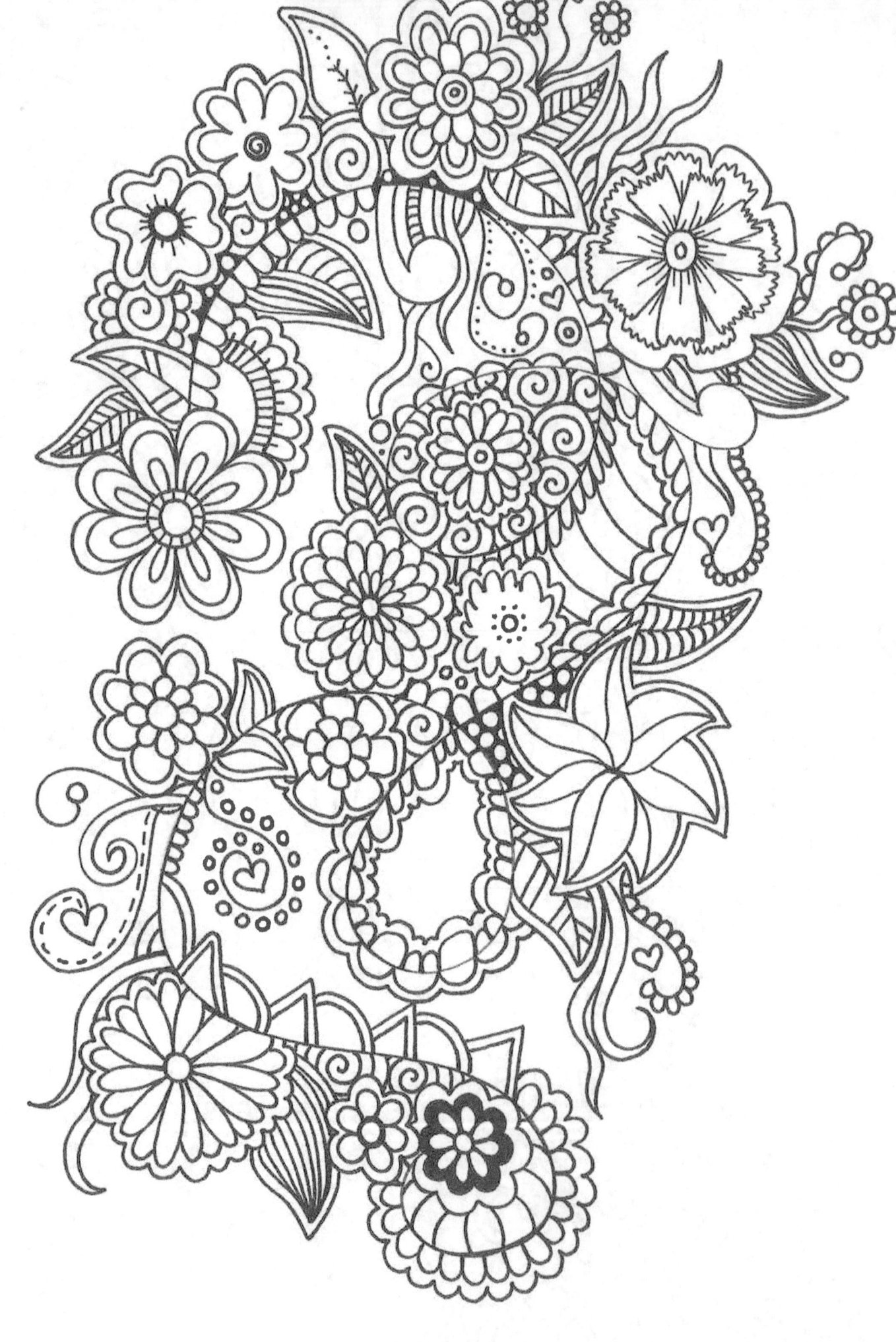

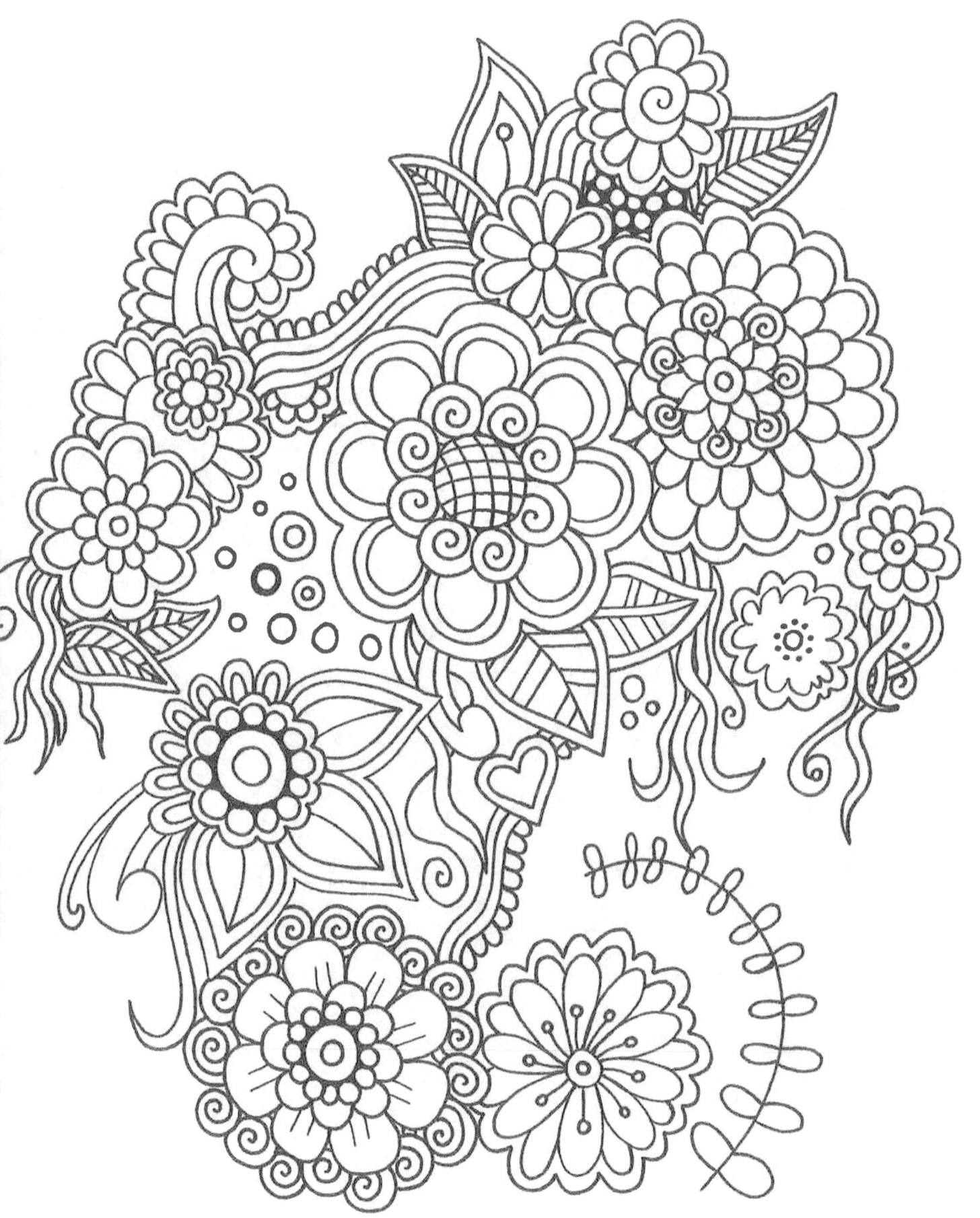

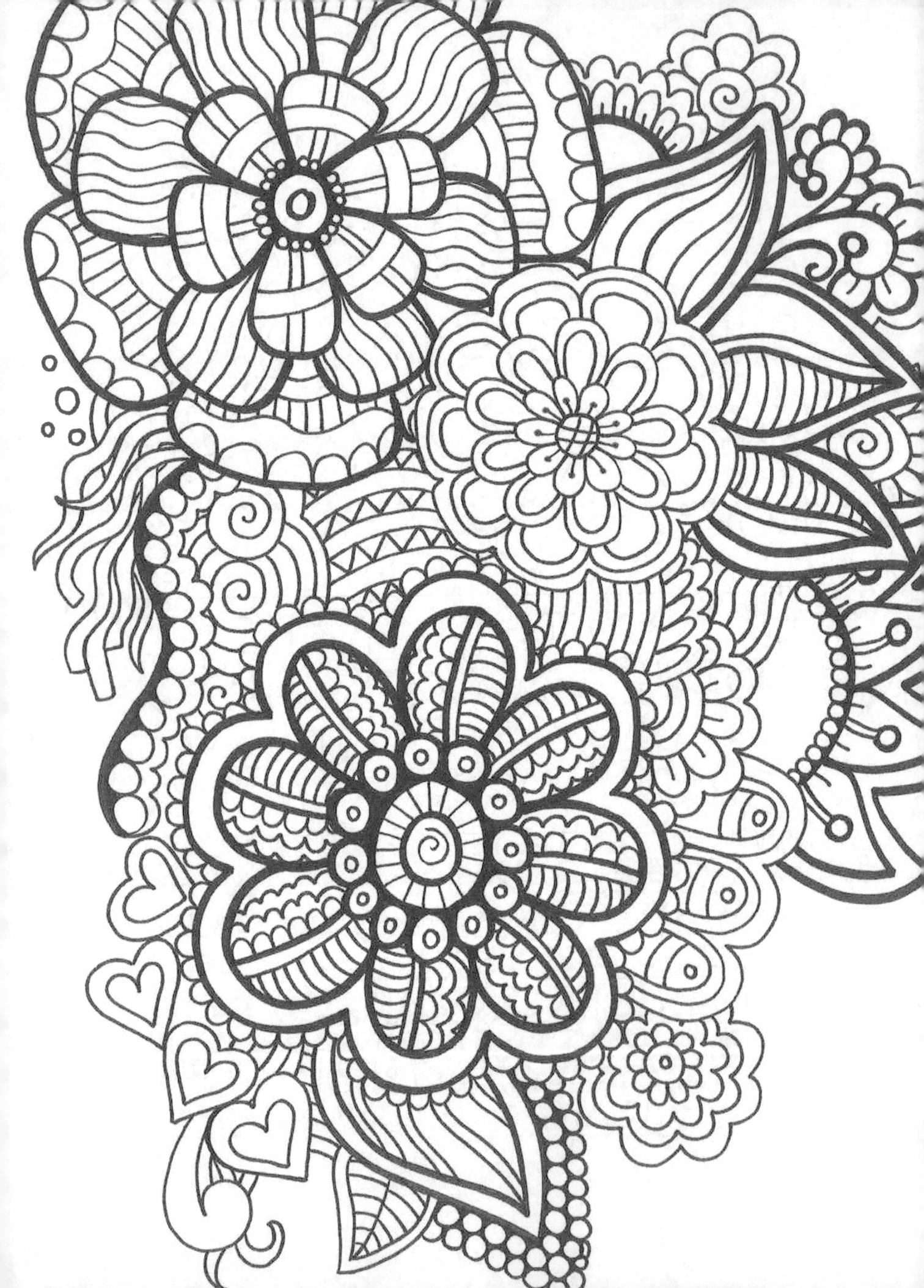

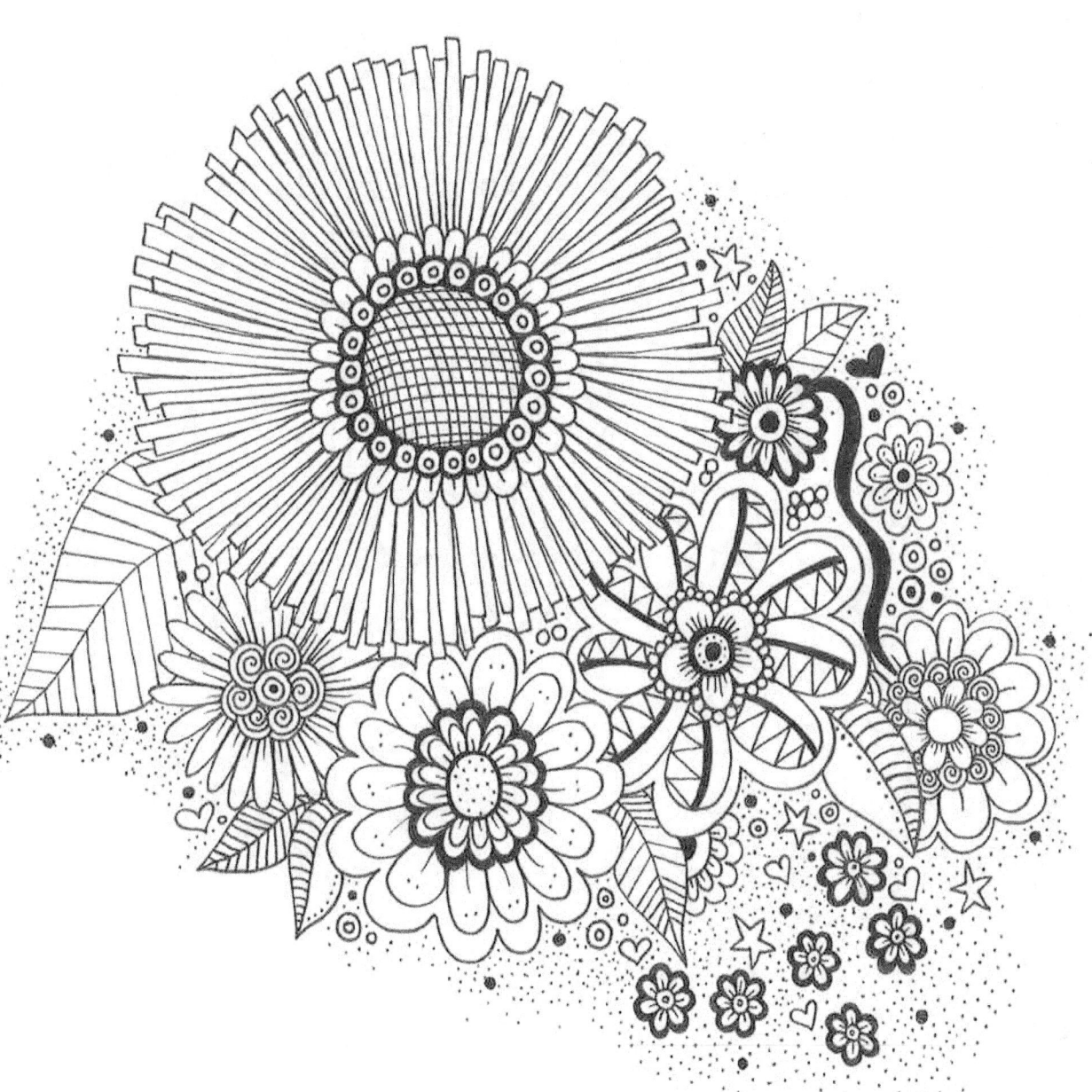

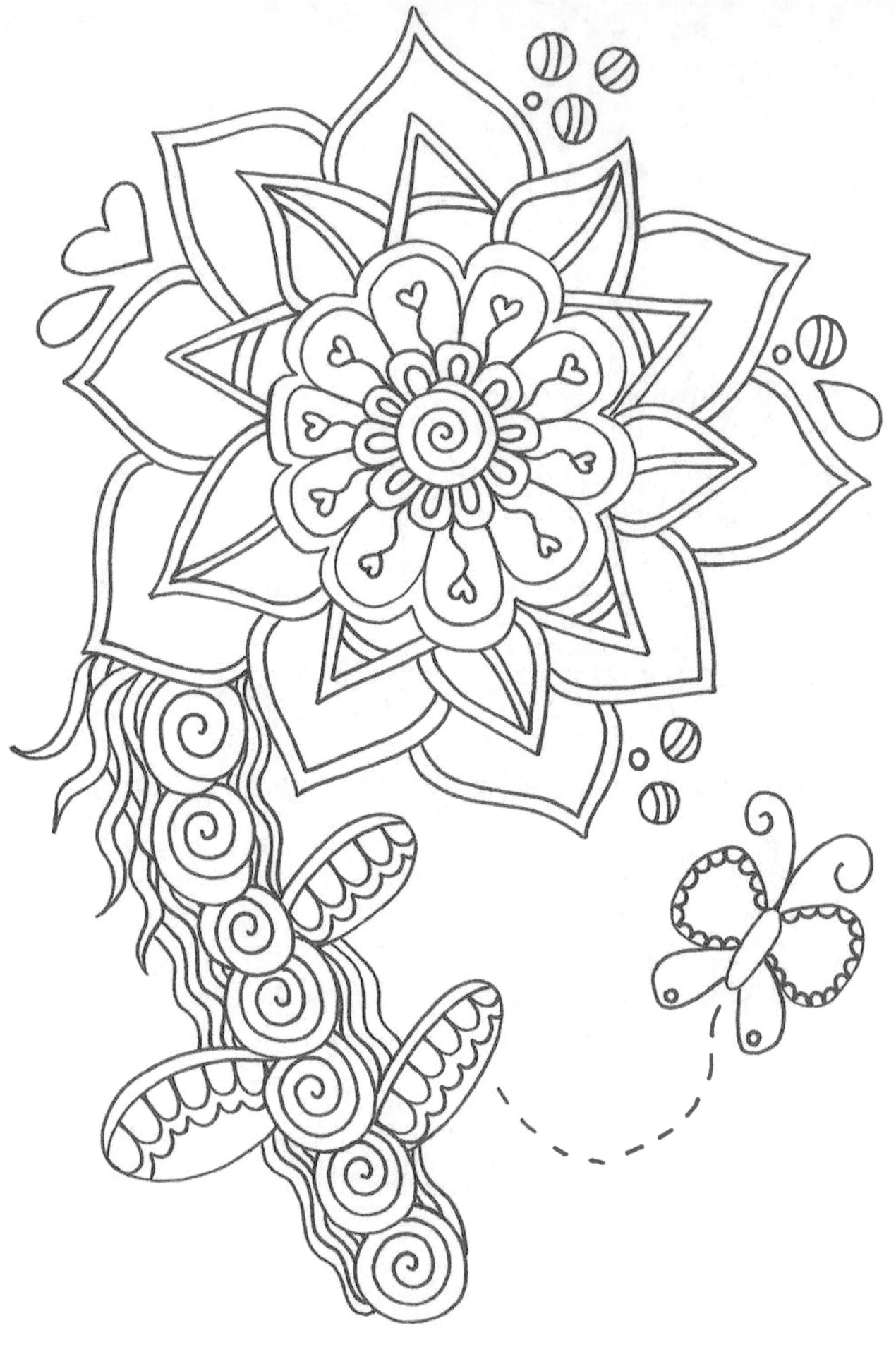

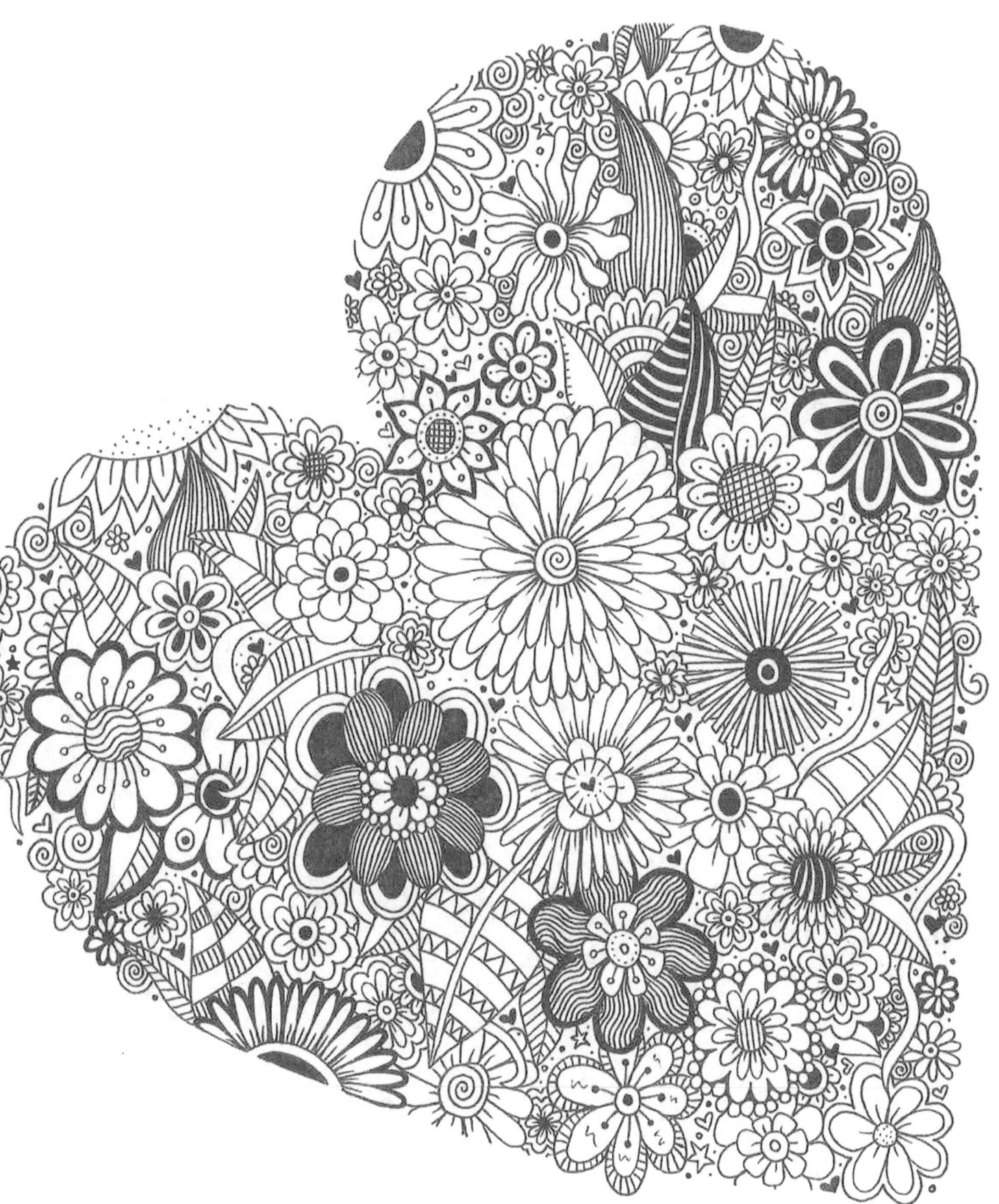

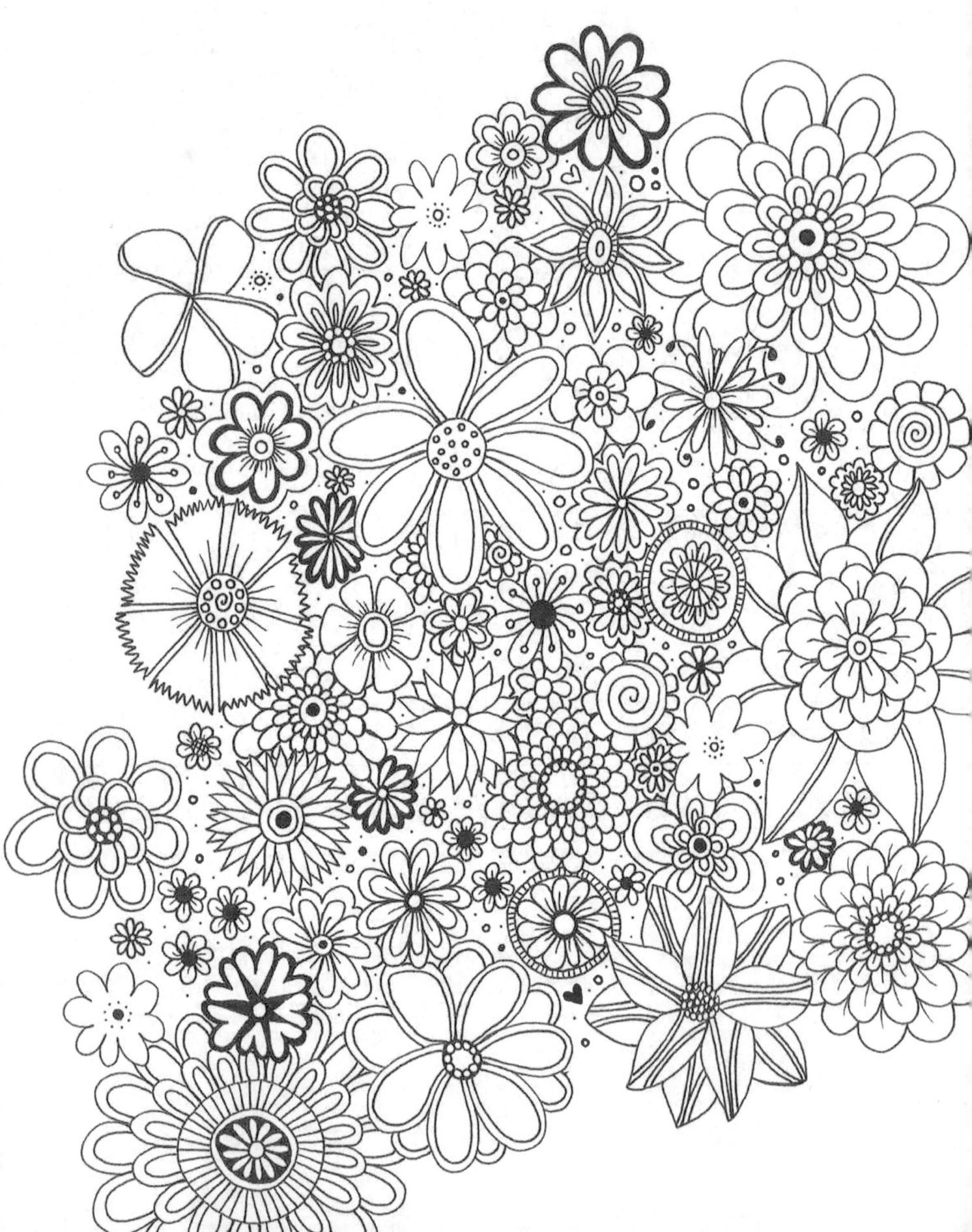

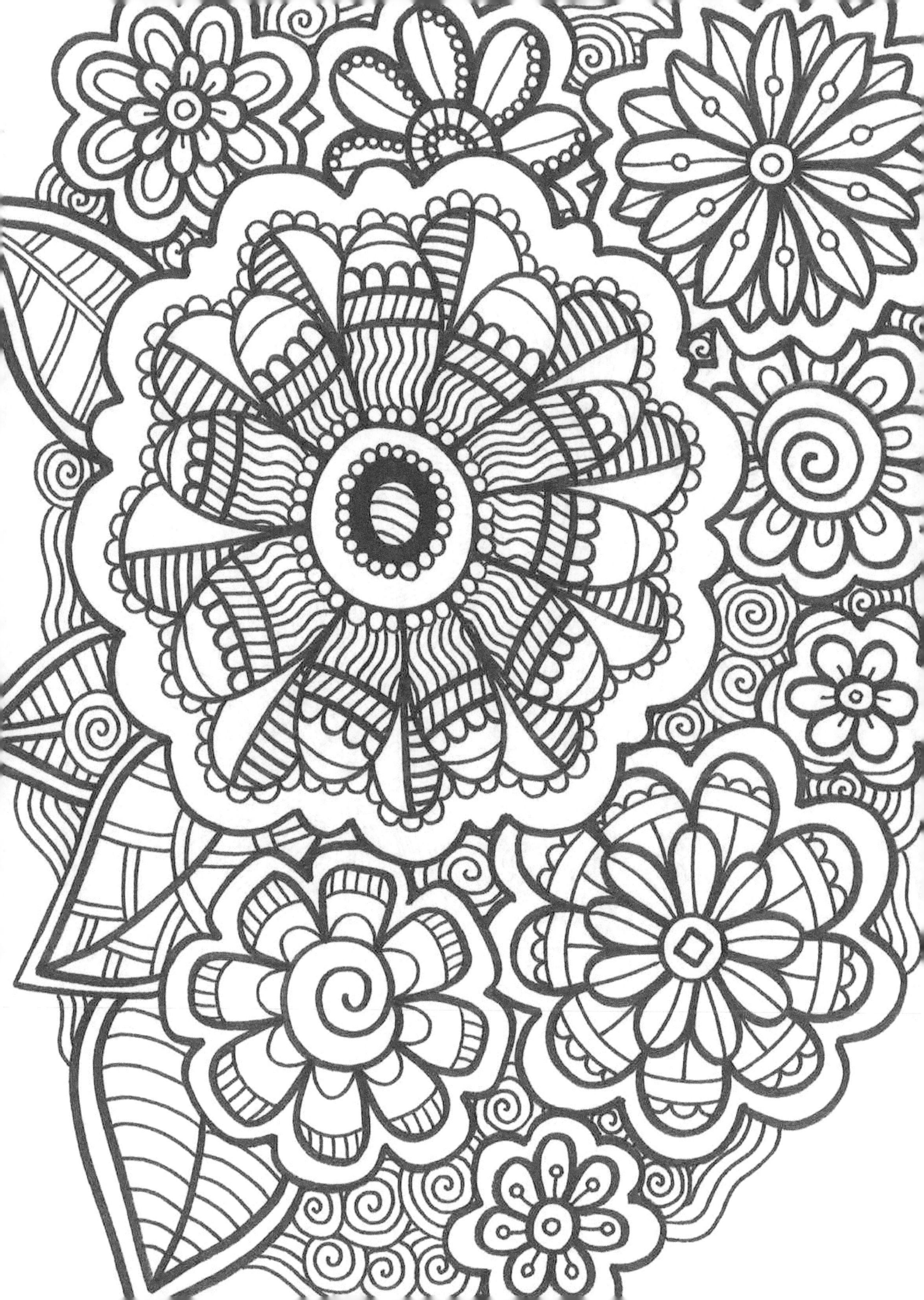

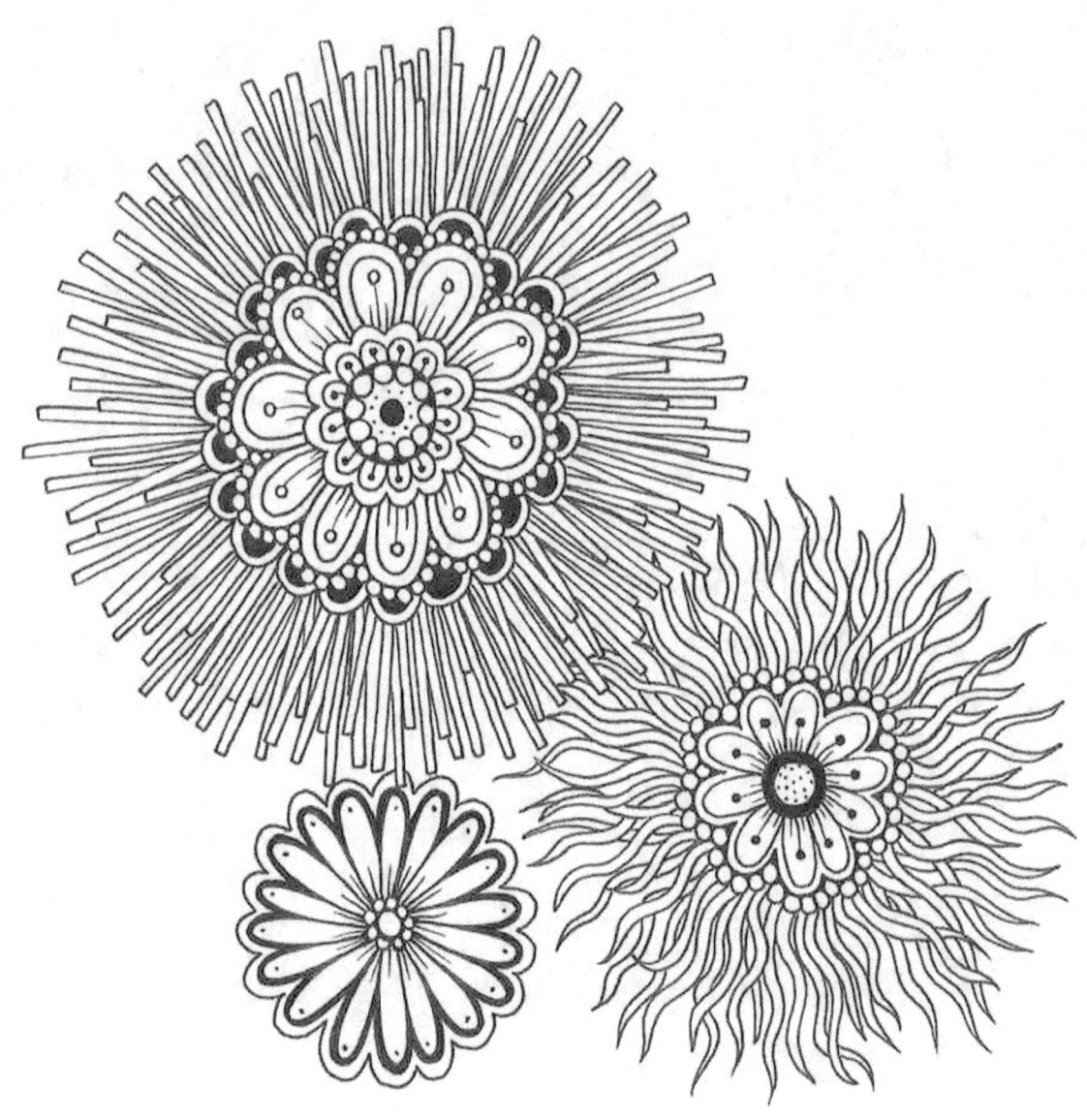

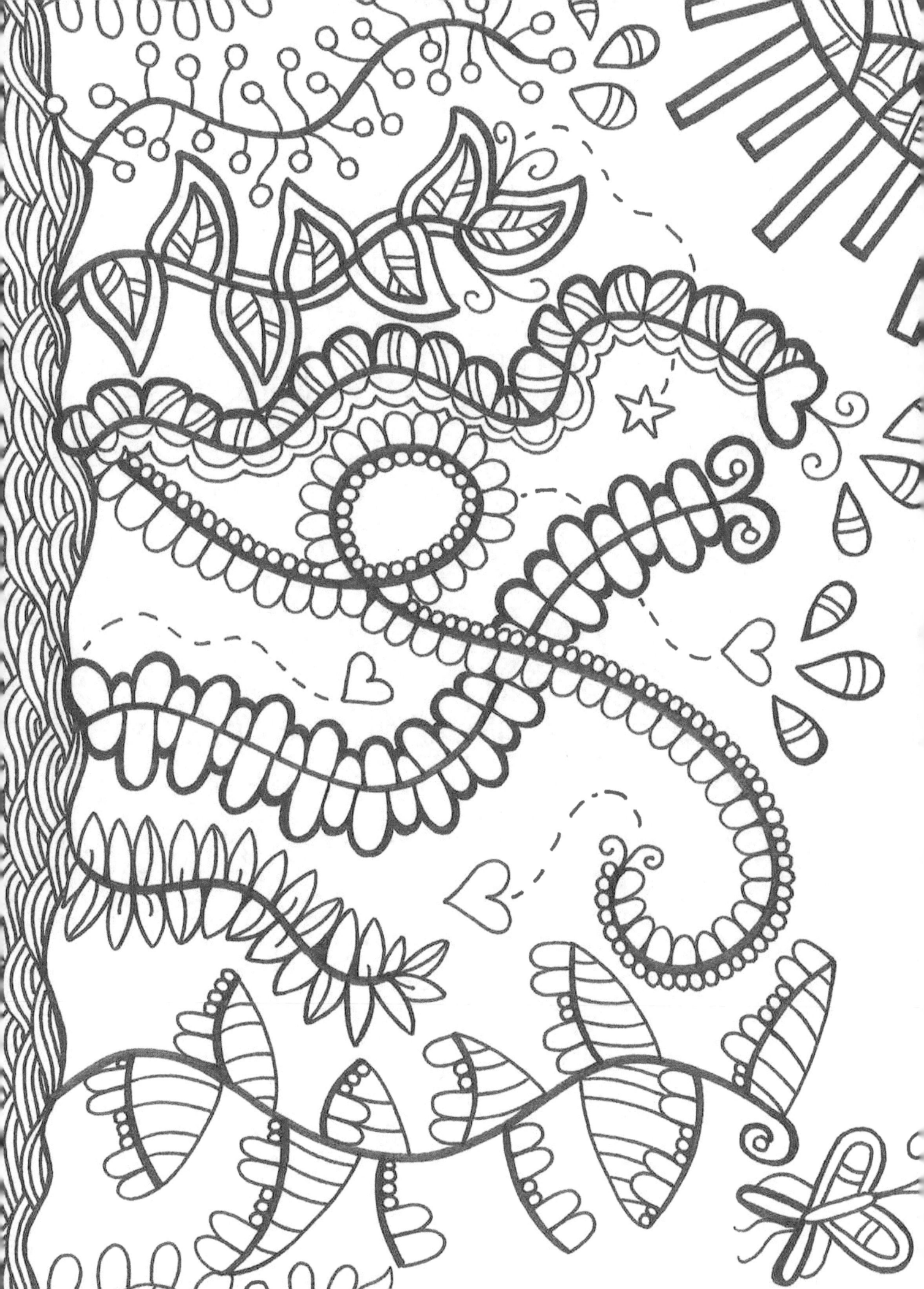

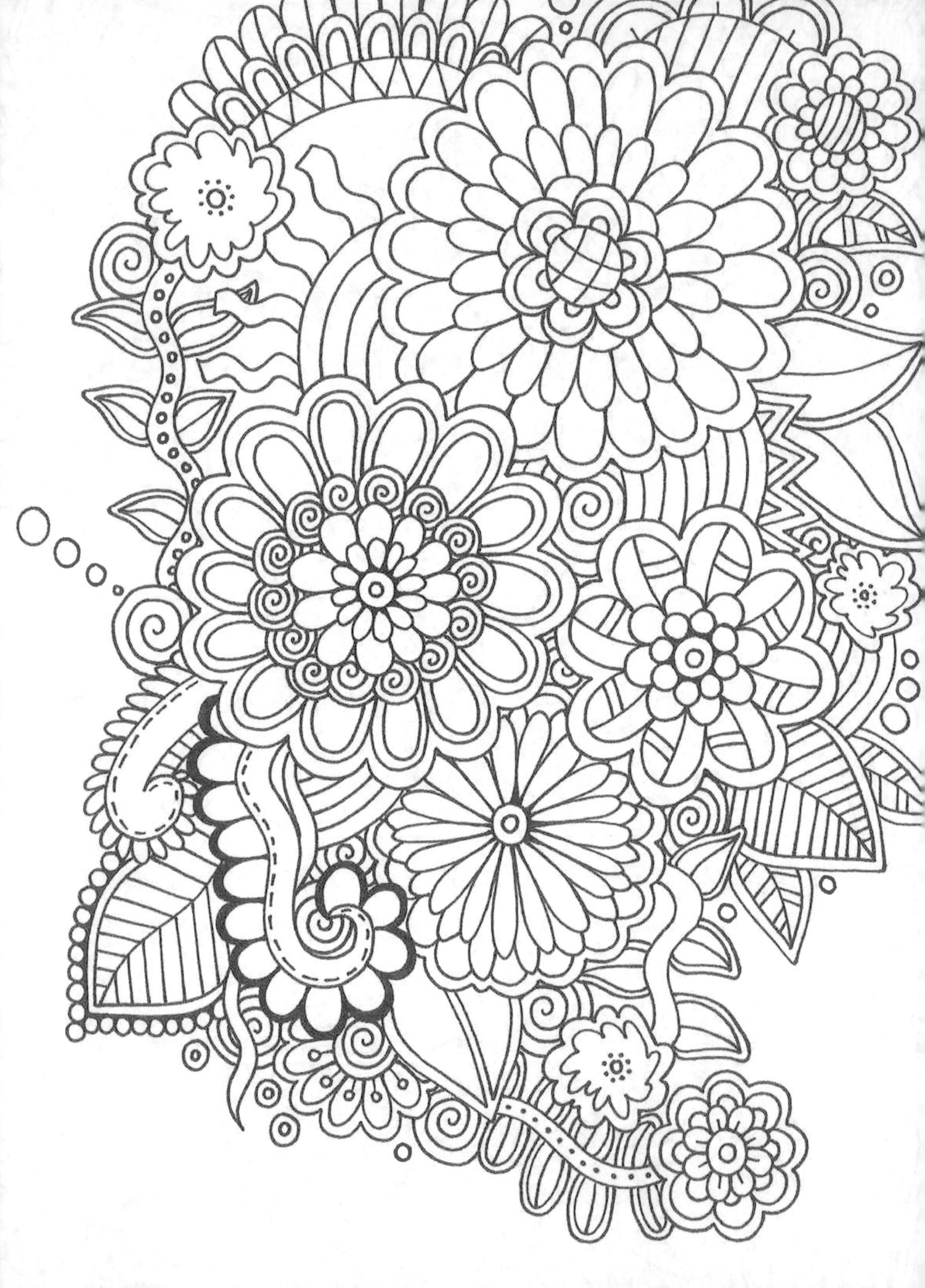

www.ingramcontent.com/pod-product-compliance
Lightning Source LLC
Chambersburg PA
CBHW080534190526
45169CB00008B/3154